# Imagine Flying

by Meredith Stoudenmire

People always think we are sleeping, but we're not. I'm so conscious of every little thing going on around me all the time. The storms coming, the saturation of the rain and then the sun drying it all away. The growth and death all around. So awake.

Is it true that you were making art even at a young age? There were some interesting drawings that brought visitors from miles away. Was this the beginning of the idea that the answers could be found on your mountain?

Wow Debbie, you really did your research! That was many millennia ago. Yes, I was wanting to mimic the zigzag patterns that the coyotes make running along my sides. I developed the ability to make small eruptions and control the flow so that the lava would move in just the right way. The local folks were pretty excited, and word spread, I guess.

And your work has been heavily influenced by the community there in your arc. Can you tell me about some of those relationships?

Well, I'm still the youngest. Benny and Junia have been around since the landscape was very different than what it is now. Benny's always coming up with the best jokes and Junia's laughing vibrates all the birds out of the trees. During Benny's 7th eruption, Junia was badly damaged and kind of crumbled. It was a few hundred years before she emerged from that. But she was always there. We lost our very close friend, Lottie, and the art helped us grieve. We would talk through our feelings and realizations, remember the best times with her, and Benny and Junia would even help me come up with creative ways to express all that.

You've been lucky to have them.

Definitely. They're the ones that knew first about the comet.

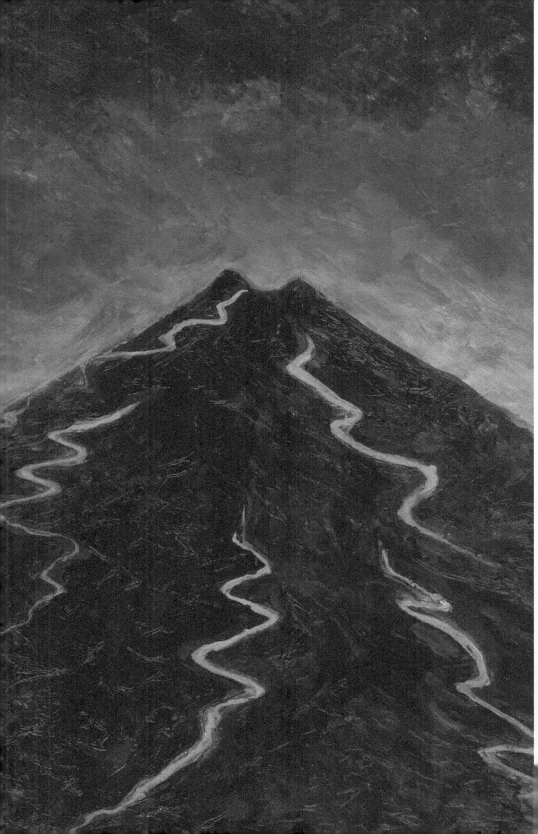

Sept 13, 2018

There have been so many big rains since Lottie's been underwater – it makes me so sad that she can't feel them anymore. We used to laugh and laugh at how the people would scatter. Day after day, year after year in this cozy mountain range, we developed this hilarious banter. She could see the black clouds rolling in from her side of the arc and would say "Here comes the downpour! Watch for the boats!". We both loved how the water ran trenches down our sides. It felt like starting over somehow, from scratch. Because when the sun came out again and the animals emerged from their hiding spots, the air felt so light and the trees would stretch, it seemed like a new chance to be excited. She was always so excited. But underwater folks have cool stuff to chat about, all the different kinds of fish and all that. I'm sure it's hard for her too. My constant hope is that the plates will shift one day, and she'll come up here with us again.

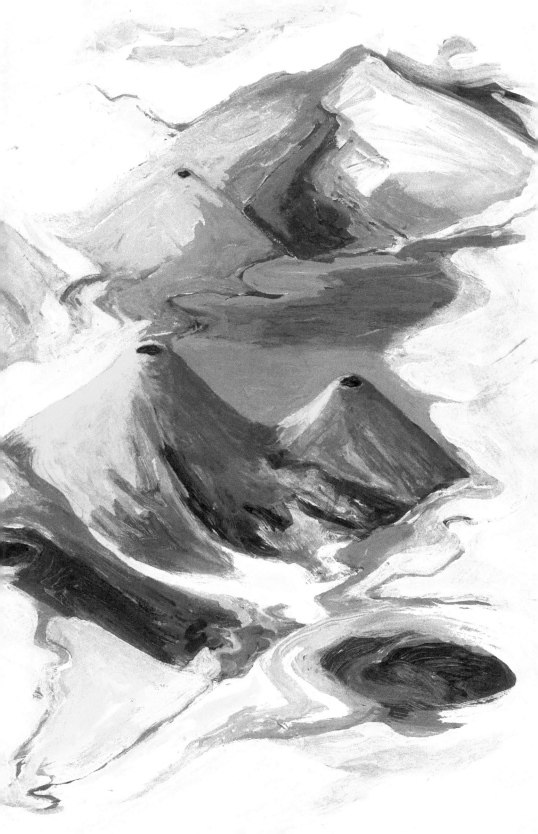

Dec 15, 2018

Junia said that something out in space is coming this way. She can feel a special pulse that's different from the underground vibrations. Some of the old folks up north taught her the sensitivity whenever the last comet came, a long time ago. That one was relatively tiny and landed out in the ocean, but they said the tremendous waves soaked the waterfront houses. I wonder what that would have been like for the sea folks. My imagination lingered there for the rest of the day, picturing the rock as emerald green, glassy and shiny, super fast – a rock punted into our quiet bay by some giant space monster! It's hard to think about that kind of distance. This new one could land anywhere, not time to worry yet.

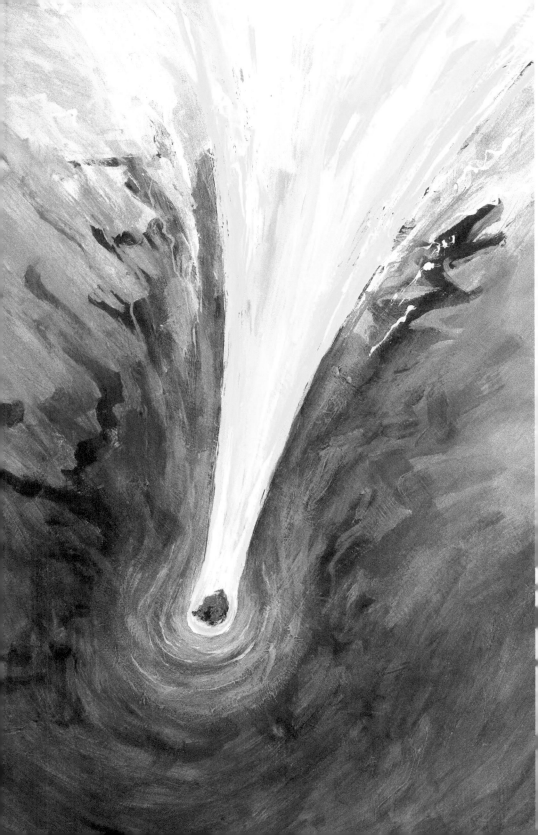

Jan 17, 2019

Falco's curious about us, so he's been coming around more and more often since we met last summer when he just came up and introduced himself. He flies around, circling my crater, trying to see in. When he first asked what's down there, I told him it's really really hot and he just stared at me, trying to process what that would feel like. He and his friends are all so graceful and free. I trace the circles and imagine what the sky would look like if there were cerulean smoke trails behind each bird. His life is the tops of trees and being high above, gliding along the trails of the creeks. Mine is just here, stuck on the ground.

I asked him, "Are you ever scared you'll crash or something?".

"No, flying's not scary. You know what's scary? Nothing is as frightening as those mountain cats. You land to find yourself a little worm or mouse or something and they've got their eyes fixed on your movements from behind a rock or wherever they hide. The game is to be sharply focused, get my meal and get out!". His laugher ruffled his brown feathers giving him a silly but serious look.

"If you hang around me, I'll warn you when they're approaching. I can feel them coming."

Falco's eyes got big, it made him happy. It's fun for me too- he can go down to the docks and eavesdrop on all the fishing conversations. I look forward to his stories about what they caught and the scuba divers and the tourists, giving me new ideas and ways to wonder what Lottie's doing down there.

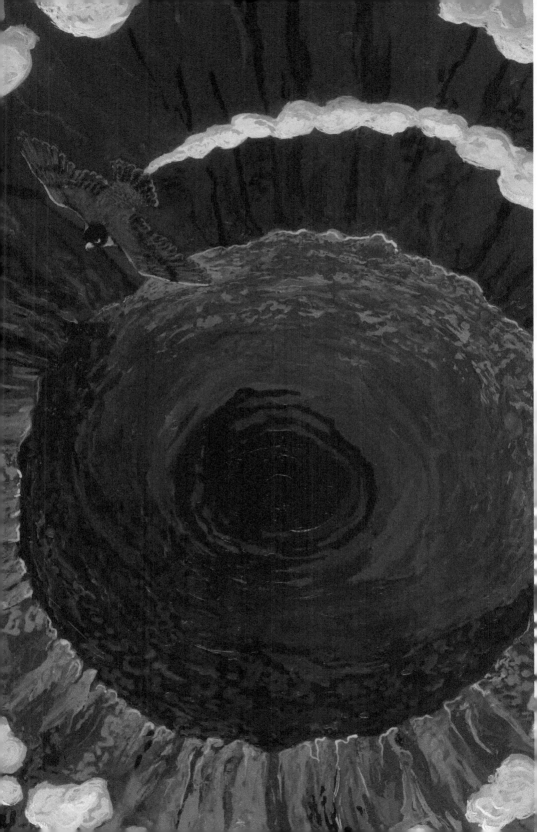

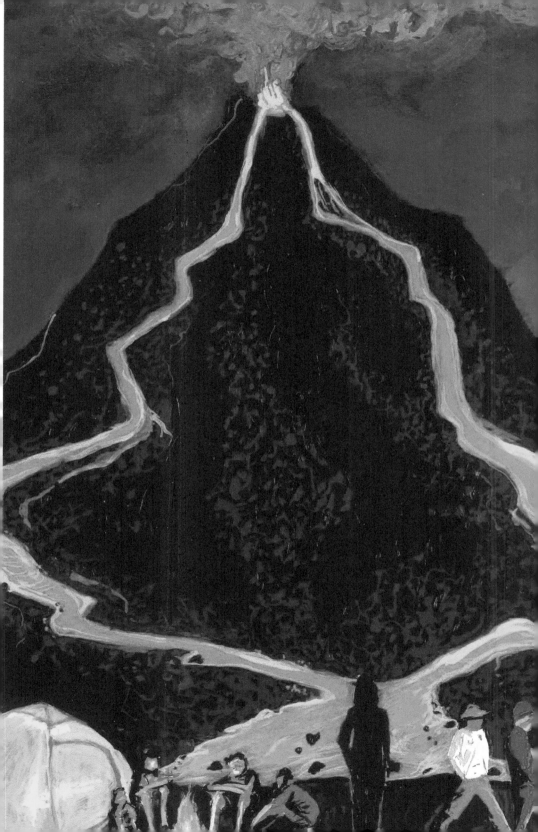

Feb 1, 2019

Even the people are starting to talk about the comet now. They think it's pretty small, the damage will be minimal, but it's definitely coming straight towards us. The mood around here is dark, kind of creepy. Folks in the arc are listening to the people's news stations and chatting about it, imagining if it hit one of us. Thinking about it gives me this sharp pang in my center that vibrates down my middle and gets loud. The week of Lottie's explosion felt like this. She got quiet and scared, not knowing what would become of her, hoping for the best. Everyone tried to be encouraging, but there's never much you can say. This is part of our existence, after all! It's the very nature of our being. But, when the time finally came that night, it was just awful. I never thought anyone could just disappear like that – it happened so fast. She blew and there was so much smoke and ash flying all around and then the water washed up and she was gone, before any of us could say goodbye. Dealing with the loss of her has been tremendously painful – she was so fun and special. I gotta stop listening to the chatter, just focus on the weather and the birds and the patterns.

Feb 28, 2019

"Hey Benny, I wondered if we could talk a little bit about my last eruption? You know, the…"

"The one a few years ago? Yeah, that one was pretty spectacular. You put on a good show. Remember how all the people came up here and watched for days? Even camping out, playing hacky sack." Benny laughed.

"Yes, it was really dangerous! What were they thinking? Eruptions are unpredictable! The kids knew not to come- they hadn't visited for weeks before it happened. I've just been thinking about it a lot lately. A couple of little ones paddled up on a kayak this morning and hiked up along the creeks. They just wandered, looking for caves. They had a list or a map or something"

"You know they believe you are the special one", said Benny.

"I know. Because of the Legend", I responded.

"That eruption changed everything around here! I mean, they were able to build that huge fort because of the expansion of the land further into the ocean. It made them less vulnerable to attack."

"And now they risk their safety to pay homage."

"It doesn't have to make sense, V, you make them feel something. Like they're invincible. They become brave.

**DM:** I want to hear everything about that night. Could you see it up there?

**V:** Yeah, well you know Junia had been monitoring it long before Falco was getting news down at the marina. A woman up in the desert had spotted it with her telescope. But we could see it coming down for a week or so before...

**DM:** Before it landed!

**V:** Yes! The event that changed everything. I was worried, I had a feeling it was coming at me.

**DM:** You did?

**V:** I don't know, we knew it would be within a few miles. But it got brighter and brighter and I could see the green and the pink and bright tail and deep down I realized that this was going to be good— I needed the shakeup.

**DM:** There had been a lot of sadness in the years before that.

**V:** And tremendous fear. My best friend had sunk into the ocean. For so long I was anxiously scared of annihilation and then here was this "interstellar object" was speeding towards me and I was exposed.

**DM:** What were those last minutes like?

**V:** Like a release. I let go.

**DM:** Let go?

**V:** Of the ground beneath me. Of the safety I craved. I woke up. I was ready for whatever it was bringing, the unknown.

**DM:** The unknown.

**V:** Yes. And did I venture into the unknown!

**DM:** Yeah, tell us what happened next.

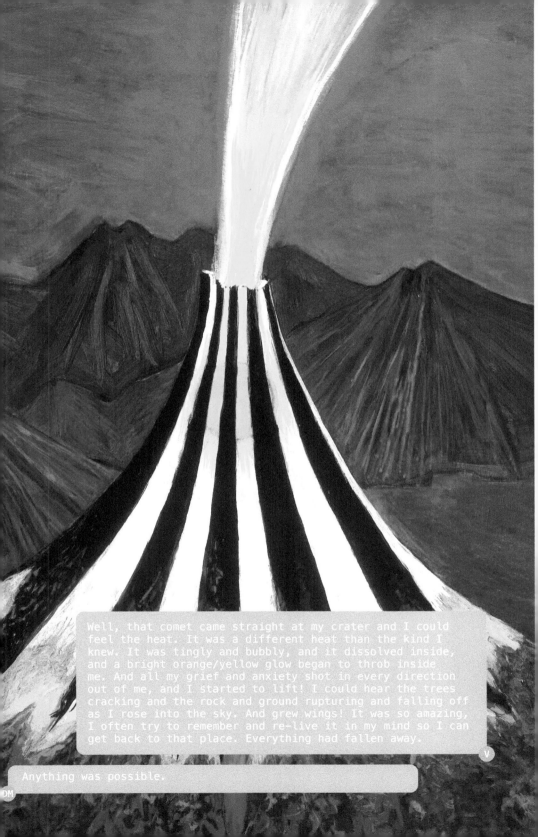

Well, that comet came straight at my crater and I could feel the heat. It was a different heat than the kind I knew. It was tingly and bubbly, and it dissolved inside, and a bright orange/yellow glow began to throb inside me. And all my grief and anxiety shot in every direction out of me, and I started to lift! I could hear the trees cracking and the rock and ground rupturing and falling off as I rose into the sky. And grew wings! It was so amazing, I often try to remember and re-live it in my mind so I can get back to that place. Everything had fallen away.

Anything was possible.

Mar 2, 2019

I've just spent the last several days FLYING!!!

When the comet entered my crater, there must have been some kind of alien space magic on it. All at once there was light shining out from my center and a high pitched ringing sound and these cool stripes emerged on my sides, what a spectacle! Then there was this rumble in the ground and it got quiet for a second and as my new body ripped from the ground, wings like a bat's pierced through my supple skin and I could move them up and down- there was this WHOOSH WHOOSH as the wind blew down into the trees and my wings took me up up up! I felt like I was going straight where the comet came from- into outer space. All around me was the yellow glow from my chest lighting up the sky. The sun was just starting to rise, and a pink glow bounced off the trees and houses and I could see all the way to the Islands way way out! I was quite a lot smaller and agile, and my wings were strong. Like the birds! After going around and around in circles, the arc folks cheered and told me to GO GO GO, so I went. Down to the docks and along the coast, the people looked up and just stared and pointed, spinning around like a lunatic, showing off- also crashing! Weaving in and out of trees, the houses and boats and the fishermen's wide brimmed hats appeared below as shapes that made patterns I've never seen- circles, squares, curvy curly lines, the narrow ribbon of the river. And the kids! At once, all the children put their hands high in the air and hollered into the sky. Their dreams finally came true. Mine too. This is what it's like to be a bird.

After flying for a while, a bit of anxiety caused me to turn around. What if I ran out of this magical dust from the comet that's powering me and then I'm too far away and can't get home? It was best to come back here and think. In this very moment, I'm sitting on Overlook Rock. A flock just flew over and waved. I'm a member of their club now and it's exhilarating!

Mar 3, 2019

Last night was actually restful. I curled up in a mossy area near the lookout and enjoyed the stars in totally new way. My soft and stretchy new body was sore, and my red magma tail was starting to feel heavy like it used to. When the sun came up, a beaming Falco was standing on top of me.

"Buddy!" I shouted. "It's me, Vagabond!!"

"I know! Oh my, look at you! What's with the stripes? Benny and Junia told me what happened, I can't believe I missed it" he shouted. "Let's go, they are worried about you. You have wings! How's the flying going?"

Falco gave me some lessons on the way to see the folks. We curved around the trees and grazed the water as we zoomed up the creeks. He kept looking back at me and shaking his head, "You thought you were a legend before!"

Of course, everyone in the arc was vibrating with intensity. Benny and Junia had been sending messages all the way up north with the details of the cosmic event, the magic fireball that left this gaping hole in the ground. Falco and I landed on the edge and looked down. It didn't look like much, rocks and dirt had filled in. The air felt dry and a little cold. The heat inside me grew and every part of me tingled as I looked around this place that was once both painfully confining and wonderfully safe.

Mar 4, 2019

"What we need to do is make a nice sturdy nest" Falco's eyes looked like this was the best idea he'd had in years.

"Don't you have one already?" I asked.

Falco looked up at the sky and then back at me and said "You need me right now and I think it's best we stick together", which made me relax.

He told me to go get sticks and anything I could find and bring it up to the lookout. That's where we should be, up high. I did most of the bringing and he lighted from branch to branch of the biggest tree around, directing the construction. We made it nice and soft inside with leaves. It's glorious. We sat inside admiring our work when Falco looked down and saw those cats and he suddenly ducked down behind a branch, breathing fast.

"They can't hear us all the way up here, can they?"

"Yes, and they can climb trees, so be quiet!" He shushed me with his left wing, eyes darting back and forth scanning the ground.

The cats kept going, hunting for their dinner and Falco breathed a deep sigh of relief. He gave me the whole scoop on predators. As he explained the hows and whens and wheres of the matter, my light started to dim a bit. We both noticed and it made his stories extra eerie.

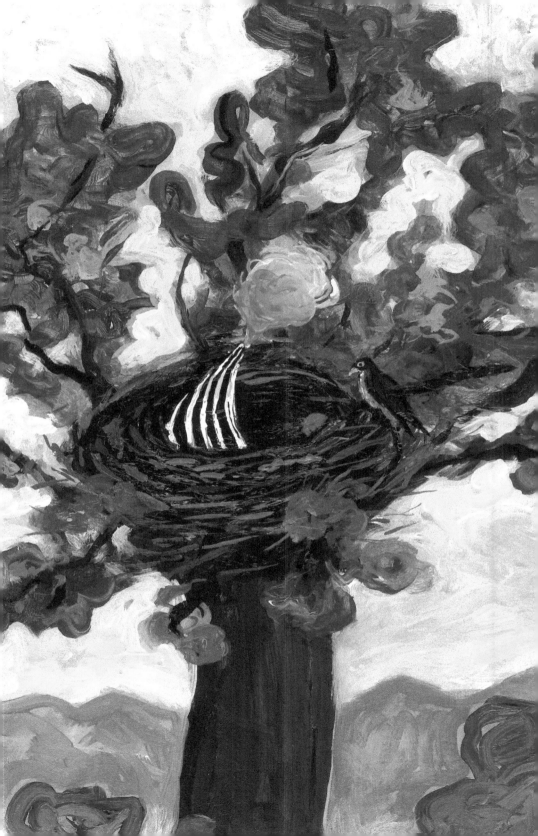

Mar 9, 2019

Be Brave.

Be Brave.

Be Brave.

I repeat it to myself. This cosmic event happened to me for a reason, I know it. I'm meant to find something, and the only way to get there is to stop holding on to the idea that I can figure out how to be safe and avoid all the scary. With a pretty good idea of where they hang around, I headed down to find the cats. When they saw me, they slinked back behind the boulders, their green eyes fixed on me.

"I used to be a volcano up there" I pointed "but now I'm some kind of a dragon and it's all because of this crazy thing that landed in my...."

They were frozen, still staring. My patience must have sparked their curiosity, and eventually they came out from behind the rocks. I told them my name.

The smaller one got closer and said "I'm Pedido. This is my sister, Joan."

Joan flashed her sharp teeth at me and spun around a few times, chasing her tail.

"What do you want?" asked Pedido.

"I want to be friends. Well, friendly. With you. Here's the situation- I've just been...a dragon... for a few days and I'm trying to make sense of it and learn how to...live! A bird named Falco is my good friend- he's helping me. I need him to stay alive. It's just the one bird, everyone else is fair game."

It seemed like a small request, really. There were plenty of small animals around here to satiate these cats. They weren't even big cats. But they seemed to be waiting for a punchline. Joan was smiling like she'd heard this story before.

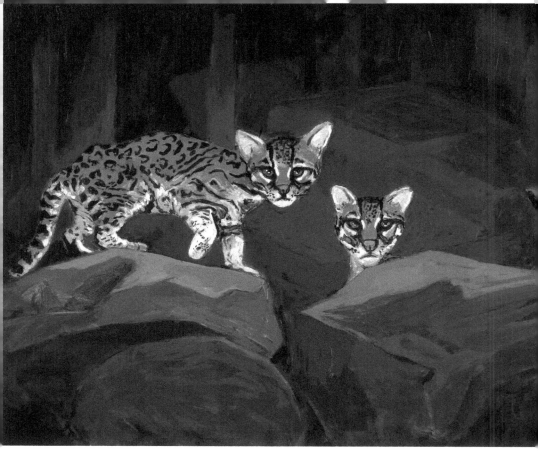

"I don't like birds anyway. Fish are much more delicious." Joan licked her paw without taking an eye off me.

Flexing my newfound negotiation skills, I suggested we head down to the bay. There were some great fishing spots in shallow water- maybe if I showed them, they'd lose interest in terrorizing the flying creatures. They didn't believe me at first, but we got lucky and caught a couple snapper right away. Pretty soon, the cats were happy and full, sunning their bellies on water's edge. We spent the rest of the day roaming around in the trees. They showed me some of the burrows where the coyotes sleep. It seemed like they were trusting me fast, but I guess they threw caution out since befriending a volcano dragon is unprecedented.

Mar 20, 2019

Joan said she had some special hunting to do by herself, so Pedido, Falco, and I went down to the fishing hole. Another clear, warm day at the sparkling water's edge, we were all feeling relaxed. Watching for fish and the winning pounce had become a game.

A canoe went by, and the people waved as they passed. Word had gotten around by now and they always kept a respectful distance, but it's my interest in them that makes me wonder about their lives. They have houses, schools and libraries, hospitals, art museums- a complicated system. I want to know more about them, to get a little closer, to steer my own canoe.

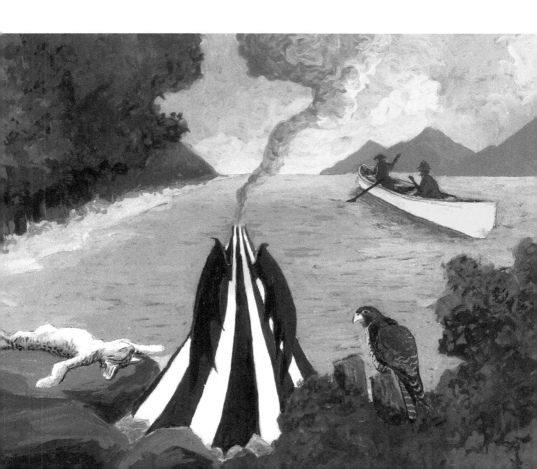

March 24, 2019

The cats and I went further into town than ever before, having turned around in previous ventures, racing back to the safety of the woods. Today, we were on the sidewalks, passing the passers-by, crossing at the crosswalks. I saw this big poster, so I flew over to check it out. The drawing was advertising plans for a giant park to be constructed right in the center of town. There were straight lines and circles, and I could tell there would be a bridge crossing the river.

"What do you think this is?" I called out to Pedido who was on the corner, pushing the walk button with his nose.

Joan came over too and analyzed the picture. "That's an amphitheater! The people sit in rows that go up a hill and there's a stage. There might be music or actors performing. Or dancers!"

"And the people are watching the performance, huh?" The shapes on the poster became animated in my imagination. This was exciting, but I didn't know why.

Pedido and Joan were sniffing the trash can next to a bench as I came out of my trance. A carved wooden cane was on the seat, leaning on the arm rest. I took it and flew over to a patch of sandy ground and began to draw. Lines and circles and patterns came out of me. My chest got bright.

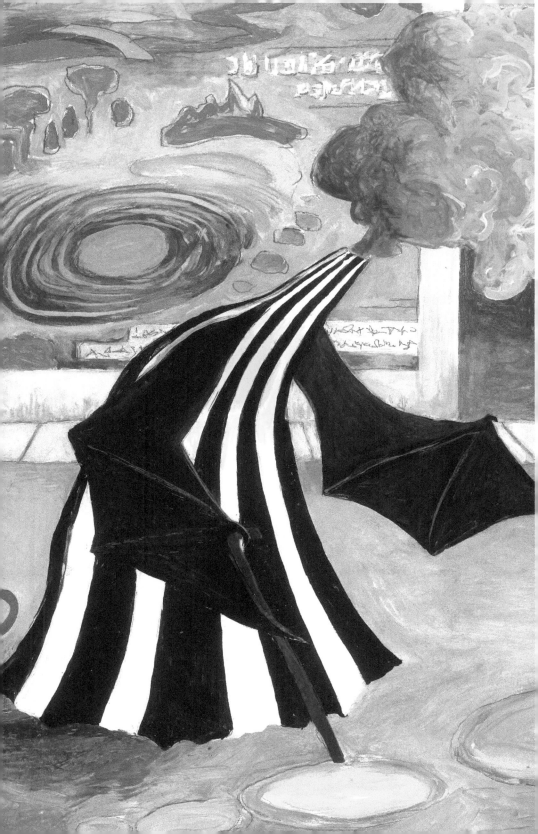

Mar 28, 2019

"I want to hunt deer like the big cats!" Joan was in my face.

Her claws were still piercing the trunk of the tree as she stretched her neck over the edge of the nest. This is what it's like to be Joan's friend. I laughed. Falco peered over the curve of my tail, and then ducked his head back down.

"I'm bored with fish and rodents."

"That's impossible, deer are so much bigger than you. And so fast." I replied, thoughtlessly.

As soon as I said it, I knew I shouldn't have. She turned her head and I think I saw tears in her eyes. Then she growled, spun around, and was gone.

"I GIVE HER A 34% CHANCE" yelled Pedido from the base of the tree.

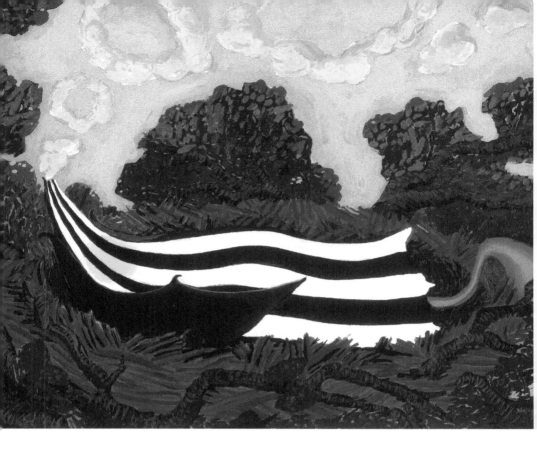

Jun 3, 2019

Every so often if I'm looking into the sky, my memories of previous eruptions come back. It gets so much hotter and the pressure releases. You're so relieved. All your feelings are coming out – oozing slowly or blowing like a bomb. I wonder how all the children know it's coming, and when they grow up, does it fade?

**DM:** And how long was it until you met Tori Mitchell?

**V:** It was a few months, the rain had started.

**DM:** She's so talented. We spoke with her last year when she did that concert in the salt flats.

**V:** Yes, meeting her felt like the second magical thing that happened that year. That day, Falco and I had decided to go a bit further flying along the coast. We love to spot swimming pools — it's a game we play [laughter]. We were probably getting a bit close to the treetops. He saw her barn first. It's an unusual shape, very tall, with a steep sloped roof. We about ran into it! There was a big open door on one side and the sun was shining straight in. We heard this gorgeous music and just followed the sound. She didn't notice us, like she was in a trance, you know? The way she touched the keys was so delicate and the rhythm made me feel jittery, but also at peace. And then it became sad, and I got sad and I looked over and Falco was feeling it too.

**DM:** And she was crying. Can you talk a little bit about what that was like?

**V:** She finished the piece and then looked up and saw us. When people see me, they're usually startled, and she was. We stared at her and she stared at us, in a pensive silence. Tori was most likely reckoning with some apprehension about being too friendly with these strange visitors as you can imagine! But we were all feeling the moment very deeply and I guess she trusted her gut. She wiped her tears off her face, got up from the bench, introduced herself and welcomed us in.

Exhausted after flapping our wings the whole day, the nest felt soft and warm. The night was a muted blue. All the internal noise I usually contend with had been replaced by great love in this moment. I shared with Falco the whole story about Lottie, about the hole that she left. Today was the first time since she's been gone that my hope had seemed to turn around.

"I got this chance for a reason, Falco. Something is unfolding here"

"That's scary, isn't it?" He looked up at me, then at the faint hazy moon, "I get scared sometimes."

The shapes and the piano tunes danced over me. Sometimes when I think about Lottie my chest light dims and I panic.

Falco sat up. "V, I gotta tell you something – I was up there when she erupted, I saw her get swallowed up by the ocean. Everyone had been feeling the rumblings so we flew up there to see. It was dumb- I got too close and a piece of hot ash hit my wing, almost burned a hole straight through it. I was flapping around like a lunatic. The sky was pretty lit up, smoke and debris going every which way. Nobody could see where they were going. I just plummeted into the trees. I landed in that same spot where we were the other day, that rock by the stream that looks like a hat with a beard? Some herons found me and carried me back to their nest, nursed me back to health. It's still kinda wonky, I fly a bit lopsided. If you ever do something stupid and get yourself injured, do this." Falco's face got all distorted and he made a weird bird calling sounding like a yelp. He did it really quietly so he didn't cause alarm. "Got it? You try."

"I'm good right now. I think when it's time, I'll know what to do" We laughed and rolled onto our backs, looked at the stars.

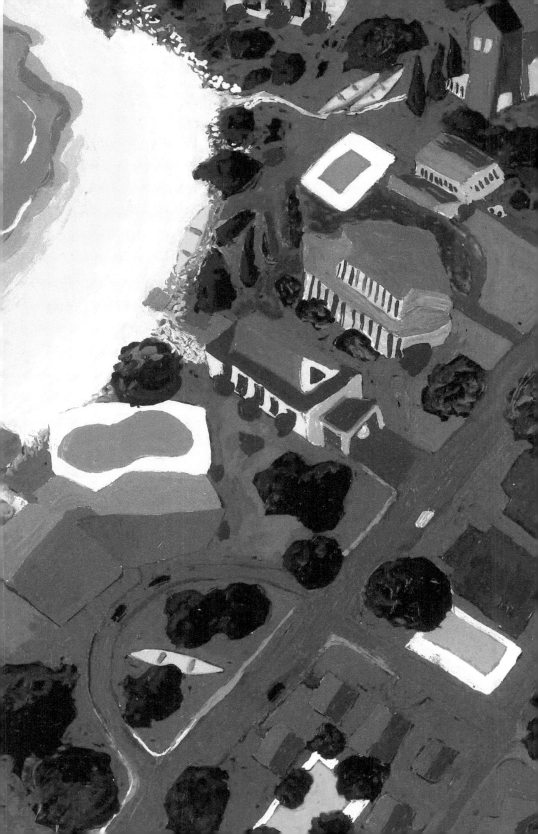

Jun 6, 2019

There was a charge running through me when the sun came up today. My red bulb of a tail was glowing bright and so was my heart. Is it too early in the morning? I can't wait. Falco was snoozing and I felt like this was a solo mission anyway. Down the coast I went! The birds in the sky around me were in harmony as the cool air blew past our bodies, a steady whistle creating focus. Pool...pool...pool...BARN! There it is! Landing in the front yard of the main house, the sharp pointy thumb on my wing reached out pushed the doorbell button. I waited, people sleep late, she's sleeping late, good grief. Then the door slowly opened and there was a different woman. Her eyes were bright, she was surprised but she knew who I was.

"You're Vagabond! I'm Isa, Tori's wife. She told me about your visit yesterday, and of course everyone around town tells great stories about you- that timely eruption during the war, and now...we are so honored! We I'd invite you in, but the house is pretty tiny." She looked behind her as she laughed.

Tori came to the door tying her robe. She also smiled. I relaxed a bit, but I was still buzzing.

"I came to tell you... I've been seeing art and patterns all night. There's a symbol and a color for your vision, and it's a canoe. A yellow canoe. And I've been hearing music, your music!"

The two women stood with mouths open. I went on about the park in the center of town and the amphitheater and how the two of us should perform at the opening. Making a connection with the people that had visited me for so many generations would show my gratitude. I changed their lives, but they changed mine too – their visits brought comfort I didn't know I needed. And now here I am in the present, evolving.

Isa immediately led the way around back and opened the giant door that led to the piano. The two of them sat down together on the bench as Tori played. She said bravery has a rhythm. It has a charge.

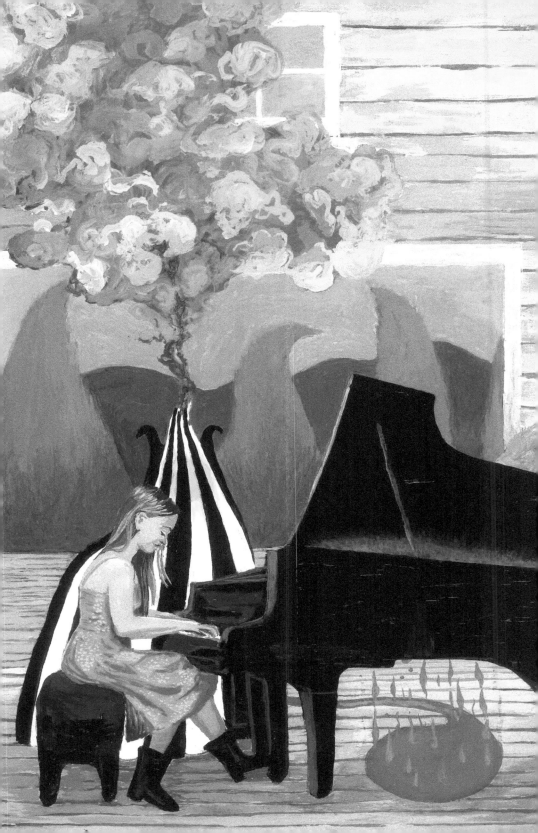

June 8, 2019

Tori and Isa had invited us all down for the afternoon. Pedido and Joan were excited, climbing the big tree in a spiral pattern as Falco hopped casually from one branch to the next. We were all glad to be united in the safety of our little clan. From the look-out, I could see some dark clouds, but they were way far in the distance. It was almost time to go.

"How long do you think it'll take to walk?" Pedido was drawing out a route on the big rock with a piece of bark.

Joan looked up from the bug she was watching, "Let's race! V and Falco can fly and we'll run and see who gets their first!"

"I don't want to get separated, we don't know where we're going" he glanced back and forth between Falco and me.

"Or what if there's a better plan?!" Falco smiled at Joan and they both got that wild look.

It took some maneuvering, but both cats climbed up between my wings. They squeezed together and tapped me when they were ready. I launched off the point and could feel the extra weight, but my light was strong today and I couldn't wait to get started on the project. Falco led the way.

Isa and Tori were out in the yard to greet us when we flew in. The cats, exhilarated, wobbled down to the ground, laughing that their legs wouldn't work. Isa had gone to the butcher that morning and bought meat for them and that was the beginning of a beautiful friendship. While Tori and I discussed art and music and symbolism, they talked hunting and fishing. Isa had a collection of bows and arrows. They planned a trip out on her canoe to the best fishing holes around.

"I think I wrote something that makes sense for this" Tori walked over to the piano. She began with something that sounded like a march. Then it got softer. I flew up into the ceiling, blowing smoke into circles that broke on the rafters. The music took a turn here and a turn there but had a steadiness about it, like you could rely on it to be there, even though it wasn't there at all.

**DM:** Okay, tell me about the sculpture. I've heard varying stories.

**V:** It was that first day that we all came together at the barn. Such a magical day. While we were all kind of occupied and not really paying attention, Falco had disappeared for a while. Tori looked up from the piano and was like "Where did he go? He was just here!" Pedido said he remembered that Falco had mentioned something about being right back. After a while he returned with all of these objects — a blue jar, bicycle handlebars, some ropes from out at the docks — a whole bunch of things— and he assembled them on the piano. He said it was a gift— he was really proud of himself. He said we ought to have a focal point to remind us about creativity. Isa welded and glued it all together later. We call it "Naked Wires". We're still looking for a name that lands better, but that's how we all felt at that moment. Exposed, but electric.

**DM:** And then what happened?

**V:** Then the whole place started to move. It was an earthquake. It had been a while since I was in tune with that kind of thing, which is sad for lots of reasons. But here we were, in this moment, and it feels like we're out at sea, like waves. Not scary, just enough to bring quiet. Until a loud crack and boom outside startled us enough to peek outside — a fallen tree had just missed the house! The tremors stopped soon after that and we were relieved that everything was still intact, including Naked Wires.

**DM:** LOL

July 15, 2019

Tori and I took a day off from working on our performance. We've been sharing our sadness about losing someone close, her mother and my best friend, and dedicating our daily practice to them. This makes me feel like Lottie and I are still connected. When I'm in the air, flying and dancing to the music, I think about the silly things she would say to cheer me up and then tell me she was "erupting with laughter". She was hilarious. It makes my chest light shine bright.

So today, I relaxed down at the fishing hole, leaned against a rock and daydreamed about being a famous artist. Joan came down to the beach and enjoyed the sun with me. She just chased the crabs, climbed a few trees, slept in the sand.

Slowly blinking open her eyes, Joan stretched long and looked up at me, "what's it like being a volcano?"

"Well, I don't know what I am now, but being a volcano WAS very different from this! The hardest part was being stuck. All those centuries and I had never been anywhere. I could see the animals and the people coming and going, I heard about foreign places, but I was never going to see them. I think most of the folks in the arc are content. I guess I was different. I am different.

"So you were trapped" Joan looked worried, "I got stuck in the creek on time, my foot between two rocks. It hurt so bad and there wasn't anyone around. The rain slashed, I couldn't run for cover. I started to cry, wondering how long I'd be there. Then a bigger cat came and was able to budge the rock and let me loose. That was only for a few hours, V! I can't imagine a whole lifetime."

The word "trapped" wandered through my mind, looking for something to connect with. I scanned the horizon and noticed how the lines get fuzzy when they are further away. Trapped.

"V, you still with me?"

Her words got closer and developed sharper edges. I looked down at her face and her black lined eyes came into focus, "Yes! Sorry, I.... but look at me now, Joan! I'm all over the place. Every minute is scary, but I'm proud of myself."

She smiled. "Yep, me too. Of all of us."

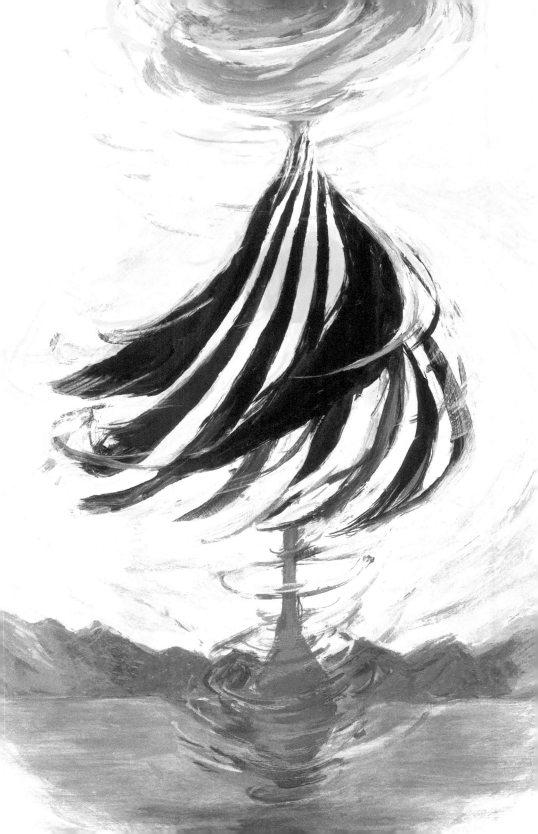

Jul 21, 2019

I wonder about the folks up in the arc and what they were talking about these days. Sometimes I am nervous to visit. My life is so different now, but I know they're excited for me. They love the stories- I can feel the ground vibrations as they send news up the chain. Maybe I was the only one that felt stuck. And maybe this was all a big relief for them, especially Junia. She was just as heartbroken as I was about Lottie. We couldn't get past it together.

The plates keep moving. We keep paddling. I keep hoping. Hoping that Tori and I make art that's moving and memorable to the people in town, hoping this stupid light in my chest doesn't go out. Hoping I stay alive. I don't know what will happen to me or anyone else, and I have no control anyway. I'm going to practice letting go of all this hope.

There was a small flat stone nearby and I picked it up. I carved H for hope on one side and F for fear on the other and I flew off the edge of the look-out. I went down the tree line and over the bay where Lottie lives deep down under. I dropped it for her. I watched the splash. As the wind picked up, I danced and spun in circles above her.

July 22, 2019

I decided to visit Benny and Junia before heading to the park site. Junia said Benny has been feeling lonely lately and singing sad songs. At first the other folks enjoyed the music, it gave the arc a sense of unrelenting melancholy, in harmony with the rainy season. But after a while, even the squirrels couldn't take it. Benny goes through this every so often. I used to empathize, and we would have long discussions about the meaning of it all. Now there's a big hole. The duality between being there as his closest friend, but also being the one that's free- it's really hard.

After the weight of that visit, my light was dimming, and I knew what was happening. I flew low to the ground in case I started to fall. Finally I arrived in town and saw the park planner, Desi, across the way. He was talking to the stone masons.

"Vagabond! So good to see you! But, I'm afraid news is not great today." Desi said, stepping over the caution tape. "That earthquake the other day damaged the foundation of all these terraces. We are going to have to inspect and repair everything. It could take months, and we're already over budget. I'm afraid we'll have to delay your performance. I'm sorry, I know you've been preparing."

Trying not to let my voice shake, I replied "Desi, please let us know if there's anything we can do to help. I'll update Tori on the new timeline. I know she'll be disappointed, but this is life on the plate boundary, right?"

We said goodbye and as I flapped my wings to head out, my chest throbbed. I got as far as edge of town and safely behind the trees of the forest, and I collapsed. Curling up in a ball, the dread propagated my body, and it went dark.

Jul 26, 2019

Four days have passed and I'm still lying here. Falco's weird distress call came to mind, but what could they do for me? I'm a dragon, dying and returning to the ground. Grounded again. Processing my panic, I play the events of that day over and over- Benny's loneliness, my disappointment. My hope. My clinging to the excitement of great things to come. No one knows where I am. What would they do if they found me? I just knew this was going to happen! There had been so many warnings, always taunting me- giving me a magic carpet and then yanking out from under me. The truth is that I have no control over what happens at all. The art and the music, the flying and the freedom, It's all spoiled by my fear.

Hour by hour by hour, the emptiness transforms into boredom, my thoughts clearing a bit, starting to relax. Painful throbbing turns into a dull, tolerable ache. As anxiety dissolves, I notice what's around me. The small skyline of the town is visible, but I'm far enough into the trees to be sheltered by mossy hollow logs, homes to the likes of Pedido and Joan. I wonder if they have been here before, there are so many nice soft spots to sleep.

We all felt those plates moving, it was real. And then the comet came and everything just exploded. My thoughts and my body race from one possibility to the next, restlessly. It's such a drastic change from sitting in the moment, but here I am again. Things come together, and fall apart, they come together, and fall apart. Impermanent.

Darkness falls like a curtain and then light again, curious small mammals sniffing around me. Sun beams burst through the forest, reflecting off every surface. Birds and bugs create an orchestra of beautiful music around me.

I'm okay like this. I have to let go or I'll always be afraid.

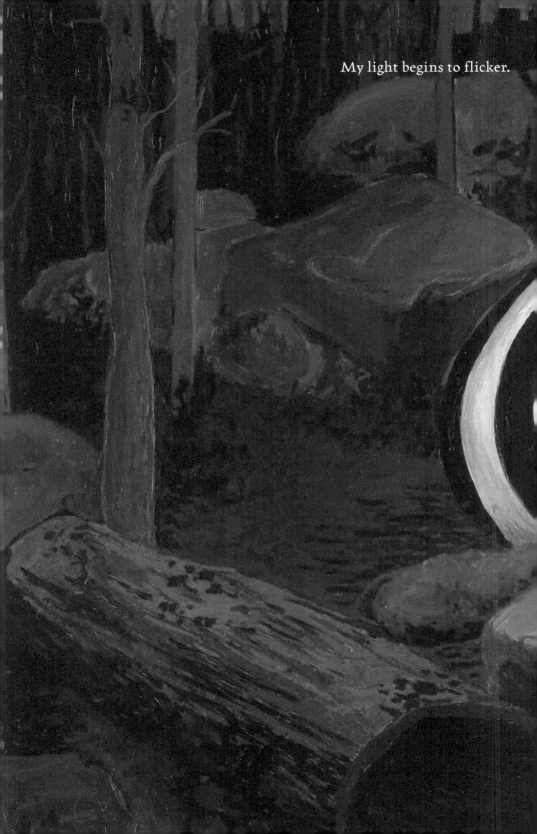

My light begins to flicker.

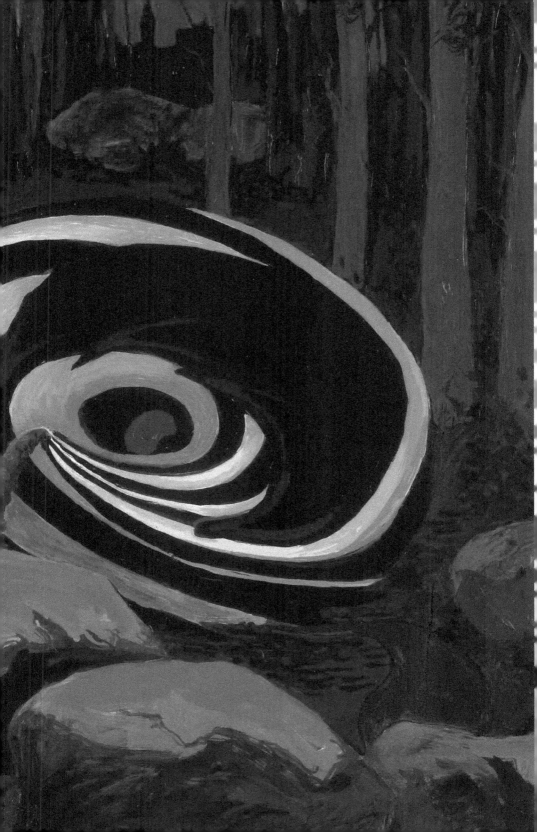

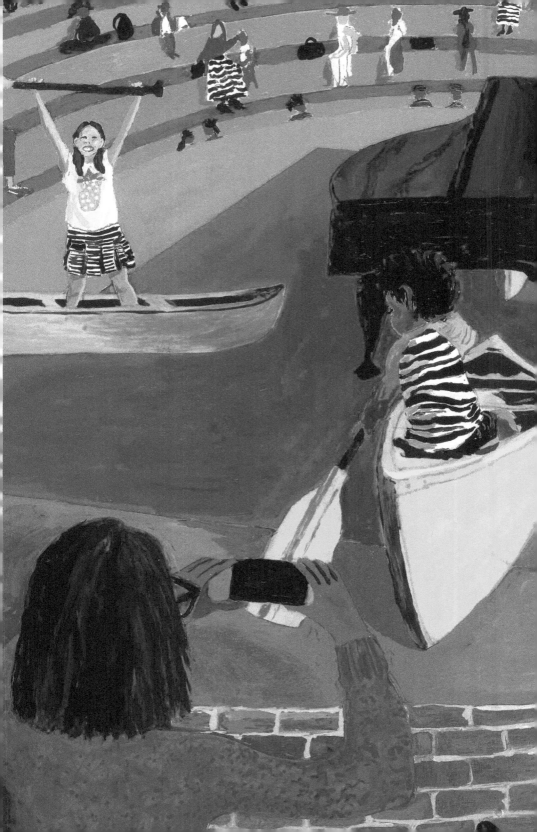

Nov 11, 2019

The day of the park opening finally arrived and we all got ready to head down there for the event. In typical fashion, Falco brought me a gift – a long blue ribbon.

"You can tie it to the end of your cane, and it'll flow around in the air as you move and spin."

Brilliant! Why hadn't I thought of this idea myself? Falco helped me get it securely attached and I practiced in the air over the nest.

We arrived in the center of town and met up with Tori and Isa under the big Ceiba tree. So many kids had come from all over the region, sitting with their parents around the central stage. A grand piano was placed there atop a bright red rug, in view of all, and four long yellow canoes pointing north, east, south and west, like a compass.

"Are you ready, V?" Tori asked, eating the last of her fruit salad. "I think we really needed the last few months- I feel more ready than ever"

Nodding nervously, I shook out my wings and dropped fear on the ground. I had been practicing during that season since I collapsed- thinking and trying not to think.

Isa and the cats sat in the grass in front of the stage as Tori approached the platform, took her sea, and pulled the microphone towards her. The crowd quieted down.

"Welcome citizens of this very special place on earth! And to our celebration of this wonderful new place to gather!" Loud cheers echoed through the park. "Vagabond and I are dedicating this performance to loved ones no longer with us. We accept that lives pass and as time passes, we are the vessels of those memories. You know, heat is an impetus, it propels us to move."

I flew in circles around the piano, my magma tail creating a red-orange blur. Tori watched and laughed.

"We choose a direction, we follow our vision, and we balance the delicate dance of holding on and the letting go."

I descended the steps to the audience and reached out my cane to the kids in front, inviting them to grab it and led them to come sit in the canoes on the stage. Their excitement was infectious. The parents ran up to take photos of their children pretending to paddle the boats.

Tori began to play a slowly intensifying melody and with her voice slightly louder "Let's honor those loved ones with this memorable experience!"

The sun was beaming light through the clouds at an angle that made everyone feel like something special was about to happen. I flapped my wings a few times and ascended high over the audience. With my cane, I spun around high in the air, a fantastic cobalt spiral mixed with the lighter blue smoke rings.

When I looked down and saw their little faces filled with enchantment, a rush of an overwhelming feeling came over me. My wings slowed and I began falling, my light fading on the way down. Tori looked up, but kept playing. Falco and the cats circled me where I landed on the grass. I could feel the vibration in the earth. And just then before my ability to process what was happening, the children all got up and came down from the stands and stage and formed a ring around me, holding hands. Tori's music got lower and deeper, and the children hummed. I knew I was being brave, but the chest light was a meter gauging my level of grasping, expecting, and holding tight. Once I could relax and accept what it was trying to tell me, the light would come back on. The love around me felt warm and moving as it filled the amphitheater. Pushing against the ground with my wings, some space was made for me to re-emerge. Everyone cheered, Tori and I finished our performance, and the mayor came out to cut the ribbon and celebrate this new public space in their community.

The cats were inspired and got really involved after that, especially Joan— she has a lot to express in herself. Isa helped them do research and make connections with promoters and we all traveled up and down the coast, playing outdoor venues. It was a new challenge for Joan where she could use her ambition and her charm.

At one of those first performances, you were approached afterwards and invited to play the Tent Rocks. How did it feel to face traveling to a destination so far away?

I do get better and better at listening to myself. That was an opportunity to see a completely different landscape, which became really important in our work. I was ready. And the desert is so amazing!

Volcanoes change the landscape, often very quickly.

Yes, for so many years, I was known for changing the landscape right in the nick of time for the people back home.

That war would have changed it for sure.

Yeah, it was lucky for them. And lucky for me too. With our art, we are honoring what the landscape gives us and honoring the citizens whose lives shaped, are shaped by, that land.

I want to thank you for taking this time with me. We've been fans and watching your work since we learned about you. So final question: What's the biggest thing that performance has taught you?

It's the perfect practice in being here now. You enjoy it fully, the players as well as the viewers, and then it's over and you're glad to have had the opportunity to experience it. Now you're different. And now, what will you do?

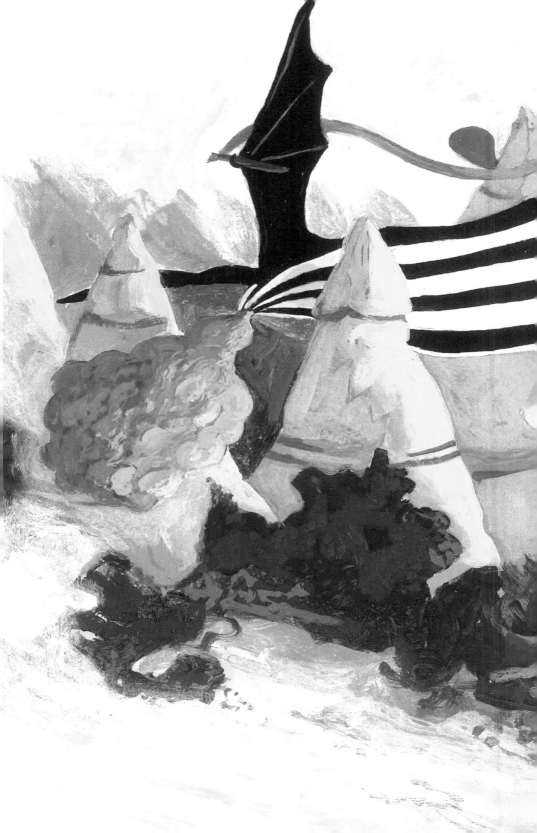

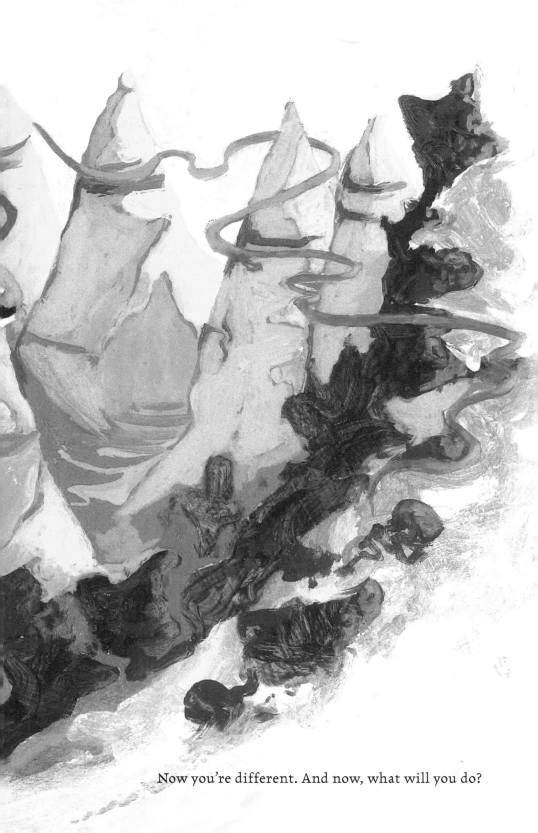

Now you're different. And now, what will you do?

9 798218 317904